Provincetown Art Association and Museum
Curator: Joe Fiorello
Photos of Work: James Zimmerman
September 2016

Sidney Simon: Idea into Physicality
By Christopher Busa

Provincetown Art Association and Museum 1995

Sidney Simon, a seasonal resident of Truro since the early sixties, is a founder of the Truro Center for the Arts at Castle Hill and was a frequent exhibitor at the now legendary Long Point Gallery in Provincetown. He died in 1997 at the age of 80. His painting and sculpture are in the collections of major museums, including the Guggenheim, Metropolitan, and Whitney. He has taught at Skowhegan, Sarah Lawrence, and Columbia, but his main source of survival has been sculpture commissions for large architectural projects such as the Four Seasons Fountain at World Wide Plaza in New York at 56th Street and 8th Avenue, completed in 1990. Such building projects typically require one-half of one percent of the budget to be spent on art; Simon is one of a half-dozen New York sculptors who regularly work with architects, Isamu Noguchi being the most famous. In an interview in 1995, Simon told me, "I love getting involved with the architect and with his building. My sculptures become so much part of the building, they won't let me sign it—you can't sign their building!"

Simon appeared on the cover of *Provincetown Arts* in 1991 in a group photo of the original Long Point artists. He and Paul Resika stood apart from their colleagues, who all dressed in colorful summer attire. But Resika, wearing a snow-white shirt, glared darkly from under a broad-brimmed white hat—the colorist impishly enjoying his secret knowledge that white contains all colors. Simon, a sole sculptor among them, also chose the color matching his white beard, wearing a white hat, white shirt, and white tennis shoes, sometimes soiled with the red clay of Jack Kahn's court in Truro. Simon's uniqueness was not only that he was the gallery's lone three-dimensional artist, but because he misses a lot of the conversation due to

his hearing loss, due to explosions blasting beside him while he drew combat scenes. His own speech (and handwriting, which he used in passing notes to his wife Renee) is clear, uncluttered, and cogent. His handicap is perhaps a blessing.

Here is how Simon sounded in 1991 when I spoke to him about how a sculptor could flourish within a cacophony of painters: "Let's talk about this group of overage geniuses at Long Point! They are the greatest tastemakers. They can hang a piece of my work and my wife won't recognize it. They make everything seem important. Sometimes it drives me crazy because I think of the gallery as a tryout place, like Summer Theater."

In contrast to the public dimension of much of Simon's commissioned work, which involves a dialogue with architecture, the 1995 Provincetown retrospective was frankly personal and quirky. Simon himself was the curator. He had been promised two rooms, but a scheduling glitch forced Simon to crowd many pieces in a compressed space. To enter, one was obliged to circumvent a boulder-sized obstruction—his terra cotta sculpture titled *Birthstone #4*, which Simon said was a "good-luck symbol of fertility." *Birthstone #4* is an enlarged version of the famous *Venus of Willendorf*, a bulbous four-inch pebble, dating from the Paleolithic period, bearing chance resemblances to the body, especially the wide-child-bearing hips that cave men knew to be so crucial to childbirth. Simon's enlarged *Venus*, now a rock rather than a pebble, is made of bonded marble and resin; her skin is the color of clean dust that has dried and caked. Some areas, like the breasts, are polished and smooth, while others along the sides erupt with fissures that reveal odd fossils of modern life—toothbrushes, light bulbs, steel screws, teeth, a fountain pen, or the impressions left by the widening lutes of scallop shells, leaving the delicate fluting preserved in the residue. A transformation has taken place. This imposing, raw, primitive introduction to his exhibition is

embedded with the diestrum cycle of civilization. Simon was on the *USS Missouri*, sketching the surrender of Japan, when only a few days earlier he had flown in a plane over the low relief of Hiroshima, where all buildings were flattened, their debris mixed together. Simon's *Birthstone Series*, one of which sits outside on the grounds of PAAM, came out of a desire for rebirth.

Simon seemed to want to signal, as the curator of his own exhibition, that what lies beyond the entrance intends to deeply engage contemporary culture, from current events to the psychology of teaching art to marvels of artistic engineering. Once inside, Simon engages the viewer to become lost in a forest of forms, almost fifty works, mostly figures in wood, spanning forty years. Part of the purpose of the show is to jostle your elbows and make you adjust your body to move through Simon's protrusions and branches. One tangibly feels touched by sculpture.

In the mid-eighties, while teaching at the Art Students League, Simon took his students to the Metropolitan Museum where he had arranged to view a collection of Rodin's stored in the basement. The room was lit by two bare bulbs. "No matter which way you moved," he recalled, "you could put your hands out and touch them."

This privileged intimacy was emphasized in Simon's 1995 Provincetown installation. To view works singly, a visitor was obliged to navigate narrow paths between pedestals arranged in a purposeful disorder across the floor. Air space, overhead, was occupied by acrobats swinging from trapezes on invisible wires. The sensation of dynamic energy was extraordinary—intensely kinetic pieces packed in a nutshell of a space, crowding the floor on pedestals or hanging from the ceiling, their motion activated by spinning fans.

The pieces were not arranged chronologically, but simulated physical equivalents of memories lodged in the artist's mind. Simon's portrait of his father, *$4.95 (The Salesman)*," is fashioned of solid

cherry emblazoned with a vest of 495 copper pennies. His father, the shoe salesman, has posture erect as a portly British butler, with the pennies elegantly countersunk into the Cherrywood, forming a shield of frugal armor and revealing clues to Simon's ability to dress up the façade of our capitalist economy. Behind his back the likeness of the father of the artist holds a single baby shoe, cast in bronze, a gesture that pays homage to the immigrant shoemaker who invented the steel-toe industrial boot for the miners in Pittsburgh and became the prosperous owner of several stores. "The Scream," a naked likeness of the artist, stands against a wall across the room, an arresting male pieta about Simon's pain after a trauma suffered by his son at birth.

Other stellar pieces included *Rhoden's Log* (1992), a sphere and a cube balanced on a fulcrum created by the tip of a cone and the apex of a triangle, so evenly weighed in equilibrium that merely by breathing heavily, the log responded. I was curious about the title, which sounded as if it referred to an obscure mathematical theorem, but Simon told me it referred to the log given to him by Johnny Rhoden, a sculptor, who had been his student at Skowhegan.

Simon's forty-year retrospective also included a sampling of work from his *Mirror Series*, small tableaux of bronze figures facing each other, yet separated by a lens, a see-through mirror, or merely an open frame. These doublings and reversals with male and female figures offer eerie echoes of the larger-scaled works in their dialogue of image with reality.

Eight of Simon's recent pieces, part of a series called *Sculpture Stands*, formed a circle in the middle of the room, providing a still center to the whirl of energy. They wittily remind us that the base of a work of sculpture may be more important than what is on top. Most of them are carved from a single piece of wood in such a way as to appear collaged together. In one, a raw section of a log, the bark left untouched, seems absurdly joined to a gleaming and beautifully

carved airplane propeller. Man and nature appear yoked together when in fact they are of a piece. In *Headstand*, a man stands on his head while the soles of his feet rise up to balance a simple block of black walnut. No doubt this is also a critique of the lofty emptiness of the minimalist cube, so reminiscent of museum pedestals for sculpture. At the bottom, emerging in low relief from another block of wood, is the man's face, a likeness of the artist, upside down and speaking as if from the grave. Simon's reversals create a resonance that remains long after the humor fades. I saw this exhibition over two decades ago, and still remember it vividly.

The War Years

A pivotal time for Simon, and a lifelong influence on his work, was on board the *USS Missouri* as the Army artist assigned to make drawings, especially the iconic image of the ceremony depicting the surrender of Japan, which he drew with his brush pen. He needed six more months to finish the painting inspired by his sketches, the last painting he did for the Army. For a period, *USS Missouri* was selected by Truman to hang in the White House.

Simon's leadership role with the War Artists Unit required that he both participate and observe. He made, altogether, ten landings by sea. To sketch the action up close, he found it safer to go in on the first wave than it was to go on the third wave, when the enemy had recovered from the element of surprise. "Because your job is to make a pictorial history, you feel psychologically as if you were in a glass-enclosed bubble that was untouchable"—that, as an observer, he was somehow *protected*.

Protected? A strange confidence on the front line! But while Simon was developing his visual way of thinking, he was also experiencing the thrill of a natural athlete, crucially skilled at achieving the dynamic balance needed between moments of stability. He remarked

in a series of interviews with Paul Cummings for the Archives of American Art, "I had become quite athletic over the years, I don't know why, playing everything from boxing to baseball to basketball. I discovered at Penn, rather than play for the college team, I could make twenty-five bucks a night playing semi-pro, two nights a week for two years." He was the center, but he said, "You didn't have to be tall in those days."

I gave Sidney tennis lessons when I was the pro at the Provincetown Tennis Club in the seventies. Hitting from the baseline on the other side of the court, I knew the distance was too far to shout to a deaf man. Instead, I simply pantomimed aspects of a stroke, in slow motion, story-boarding a motion like a dancer, and he mimicked me admirably from the other side of the net.

Farewell Dinner

At the beginning of the war, Simon met with a group of war artists in San Francisco at a seaside restaurant. Simon described the occasion as akin to "one of those sweating-out periods waiting for our boats to leave—Henry Poor, Bill Cummings, Bill Maudlin—oh God there were about ten of us having a farewell dinner."

They first discussed what kind of artists they should recruit for the War Art Unit. As they discussed how they had selected artists for their units, they compared what can be taught in a fifty-minute lecture and what one could learned by working a ten-hour day with a professional artist. From there, the conversation turned to the nature of art schools. More or less daydreaming, they conjured the idea of an art school that would not be filled with teachers, but with artists who would talk about art to senior art students, students from all over the country who may only have encountered one or two artists in their lives. The dream was to gather a group of working

artists to work side by side and learn how a professional spends a full working day, not what can be outlined in a lecture or conveyed in a brief critique.

"Basically," Simon said in his Cummings interview, "that was the beginning of the Skowhegan School," which came to pass some five years later in the summer of 1946. The founders evolved, Simon said, "a creative teaching process based on diversity of point of view, where one speaks his piece and the other plays an opposite role. The point is to get the student to create a third point of view, and that fun thing that has to do with himself. Henry Poor's wisdom was that the student grew out of his strengths, not his weaknesses."

An Email from Mark Simon, Sidney's Son
He always told me he lost his hearing because he got hit by a landing barge door coming down on his head. He was out for a long time because of a concussion. But loud explosions are just as reasonable. One long thought about Dad's response to the art of his era, as he transformed from a painter to a sculptor in the mid-fifties:

Much of Dad's figurative sculpture dealt with human psychology. If Abstract Expressionism is said to come from primitive gestures born deep in the artist, Dad ignored that to focus on people's interpersonal interactions, personal narratives. Psychology was the atmosphere that surrounded his art. Dad watched people around him, and he loved to tell stories.

His mirror series, which for the most part showed women looking at themselves and told stories about how the figures felt about themselves—a large woman sees a tiny woman on the other side of the mirror. A wildly disproportionate figure sees a normal one in a curved fun-house mirror. His carved pieces had obvious narratives—a husband and wife seesawing over an unborn baby in a rib cage. As literary and literal as these are, they are, as you note, full of visual puns and layers of meaning.

Provincetown Art Association and Museum 2016

If the multivalent quality of Simon's work was abundantly clear in the 1995 exhibition, the 2016 exhibition, *Sidney Simon: Centennial Exhibition*, curated by Joe Fiorello, demonstrates a new unity in showing the crucial transition Simon made, after the war, from two-dimensional figuration to sculpture. His friends always joked that any one-person show by Simon looked like a group show of multiple artists. In Fiorello's focused installation, Simon comes forth as a figurative artist who was compelled, following his experience as captain of the army unit of combat artists, to turn to sculpture. Something about the experience of war forced Simon to expand into a third dimension. I am reminded of the classic work on the effect of war on artists that have experienced it, *The Great War and Modern Memory* by Paul Fussell, who quotes from modern writers, poets, and artists to illustrate how irony became the aesthetic mode to remember the war. To irony, Simon added humor, wit, mirrors, masks, inversions, apertures, scrims, blinds, elevations, and other reversals of beginnings and ends. Perhaps the most arresting concept is fashioned in *Mirror #2* (1969) where a pseudo-mirror is implied by the space of an oval frame, where a frame that might hold a mirror is empty. Simon remarked to Paul Cummings, "I wanted to do what writers do, punning, quoting, making jokes."

Simon was a secret humorist, acutely aware of what Mark Twain knew: the humorist must not reveal that he is even dimly aware that what he is saying is funny.

The unit of Combat Artists was under the supervision of the Army Corps of Engineers, selecting artists from the ranks to document big dramatic events. Simon described to Cummings the engineering lessons he absorbed—"my first introduction to massive carpentry. How to move heavy weights came in very handy in sculpture." In her essay for the 1995 catalogue, Eleanor Munro spoke of the lasting impression Simon's

work can make on your memory "in flashes of original ideation." In Simon's façade for the Walt Whitman High School in Yonkers in 1958, an enormous wall of braille-like modular nibs are organized for reading the angle of the sun as light and shadow makes its ever-changing circuit across the daylight hours. Simon described the project as "building imagery into the sculpture," taking his cue from Whitman's line in *Leaves of Grass*, "Shapes ever projecting other shapes." One feels the magic in the levitation and levity of incorporating a sculptural expression with the turning world as a full participant. In one of those "flashes of original ideation," my mind conjures up the standing stones at Stonehenge, aligned to celebrate the solstice, a single day in the sun's annual orbit.

By the mid-fifties, Simon was having successful exhibitions of his paintings, but, he sensed a missing dimension—"my paintings were getting vaguer and vaguer. I found it more difficult to teach. I was caught up in the wave of Abstract Expressionism and did not feel a thing."

We must consider that Simon was a prodigy, doing mature work when he was fourteen; still in high school, he won a scholarship to Carnegie Tech, where he studied with Alexander Kostellow, known as the "father of industrial design in America," but who had also absorbed Hans Hofmann's principles of tension between planes. Simon had kept notebooks taken in Kostellow's classes, remarking in his Archives interview, "I found the amount of knowledge about space, form, depth I had heard repeated by Hofmann in one of his lectures, the language was the same."

My father went to the same high school in Pittsburg as Simon, graduating three years ahead of him, but met him in Kostellow's class at Carnegie Tech. My father, who later became close to Tony Smith, remarked in one of his notebooks, pertinent to Simon's aesthetic: "If sculpture represents the most extreme challenge of idea into physicality, its physical presence is not possible without the ever-present guidance of the shape of experience."

Simon's early architectural orientation would become a lifelong, somewhat unconscious, response to sculptural problems. Another Long Point artist, Budd Hopkins, told me how Simon's "change from painting to sculpture made the figure much more substantial."

Simon told Cummings, "One of the things about making sculpture is a feeling of labor, of working on a material that ultimately says I'm done, you can't do anything more with me. A painting only opens the door to the next painting. I pity the poor painter that finishes each painting only to discover that he has opened up something unfinished in his last painting, whereas sculpture is kind of ultimate. It just says done."

Christopher Busa is the founder and editorial director of the Provincetown Arts Press, which publishes *Provincetown Arts* magazine and books by artists and writers.

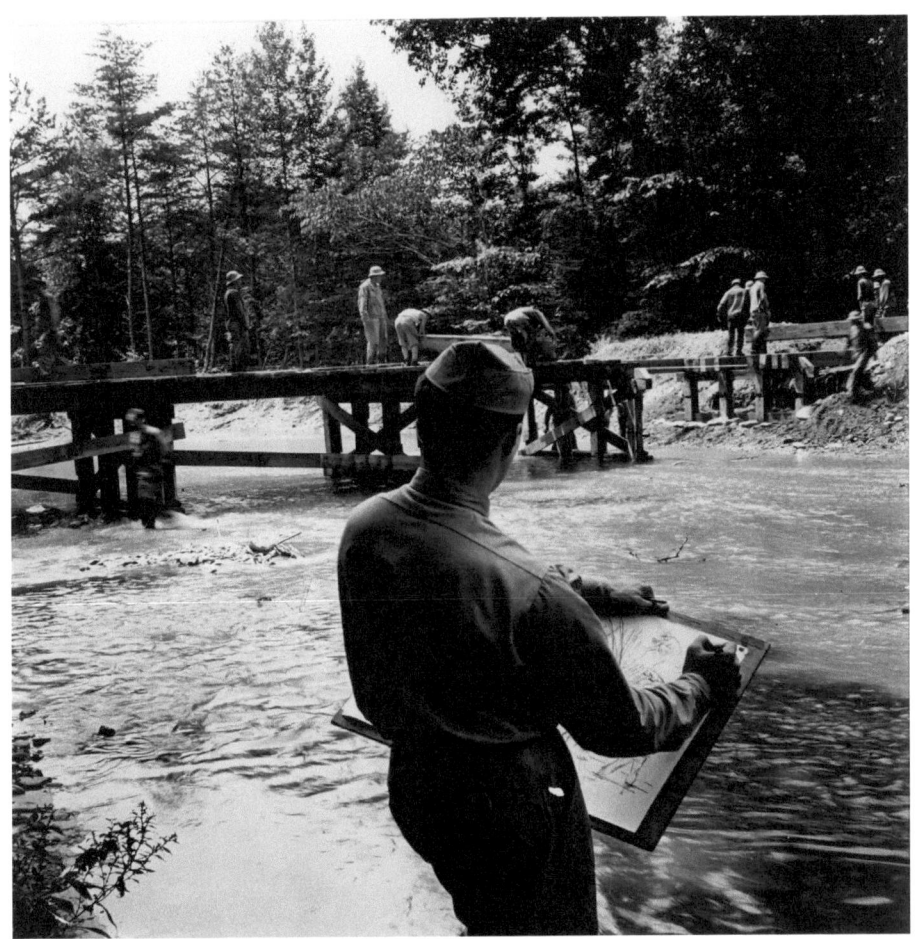

Simon sketching during the war

Selected Images from the Catalog

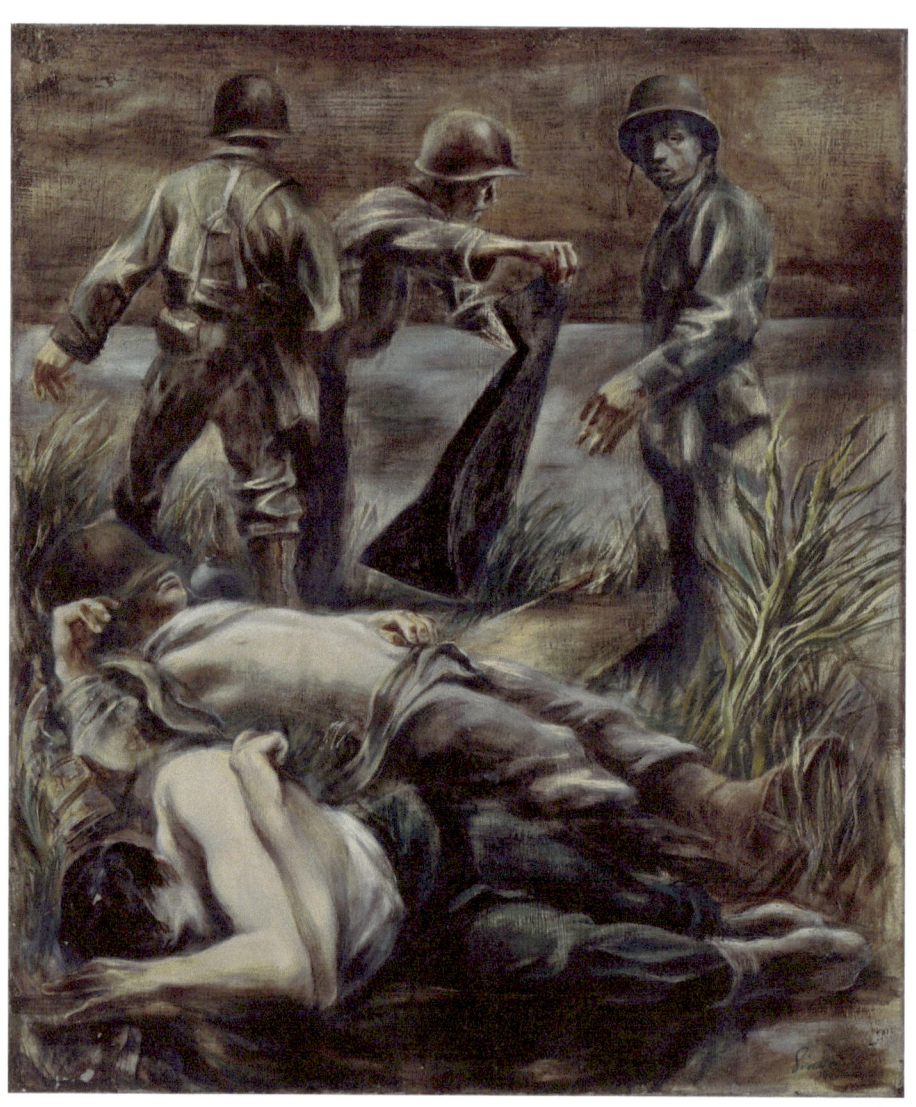
Wounded Evacuation, 1944

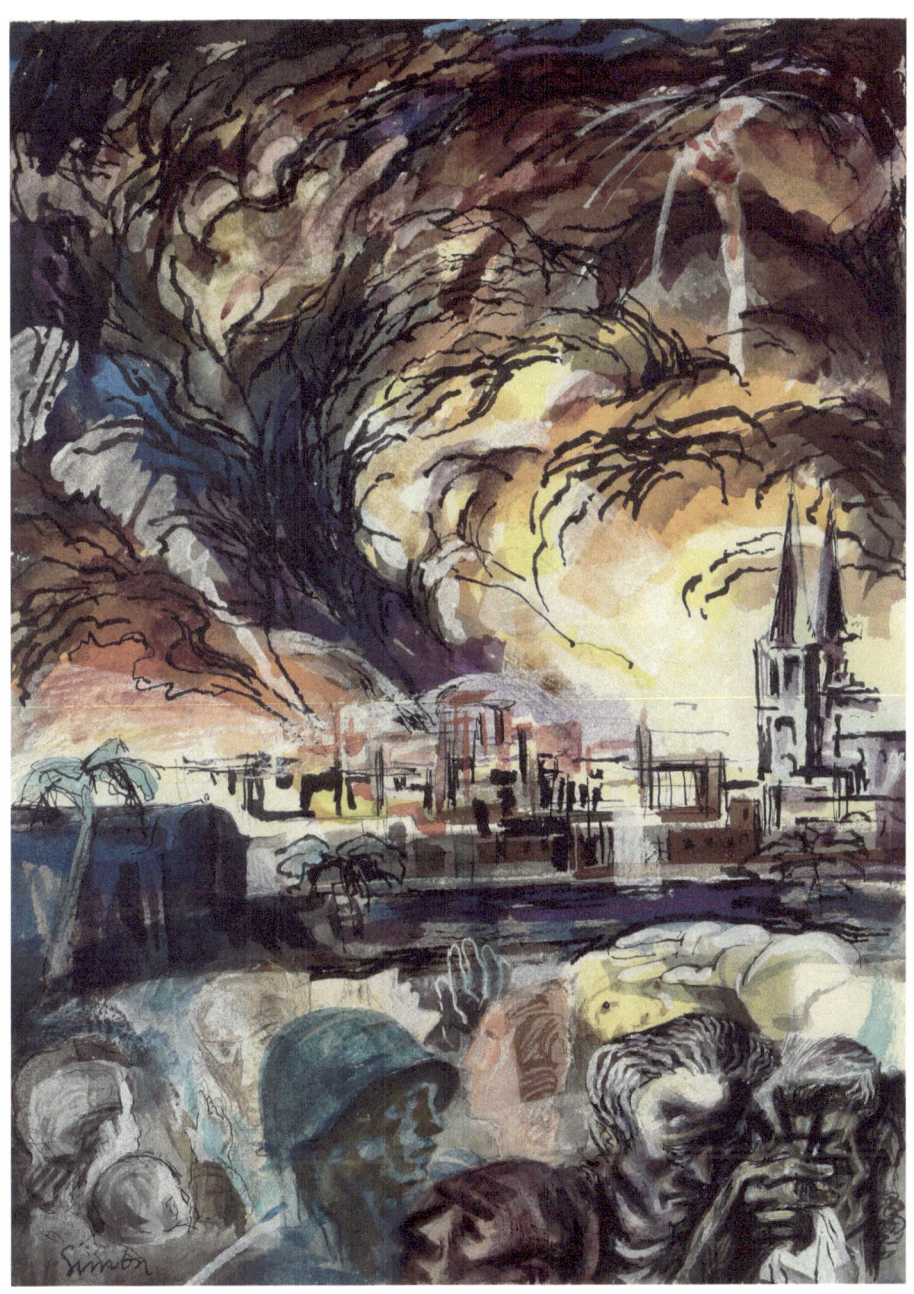

We laughed and We wept for We're Free, 1945

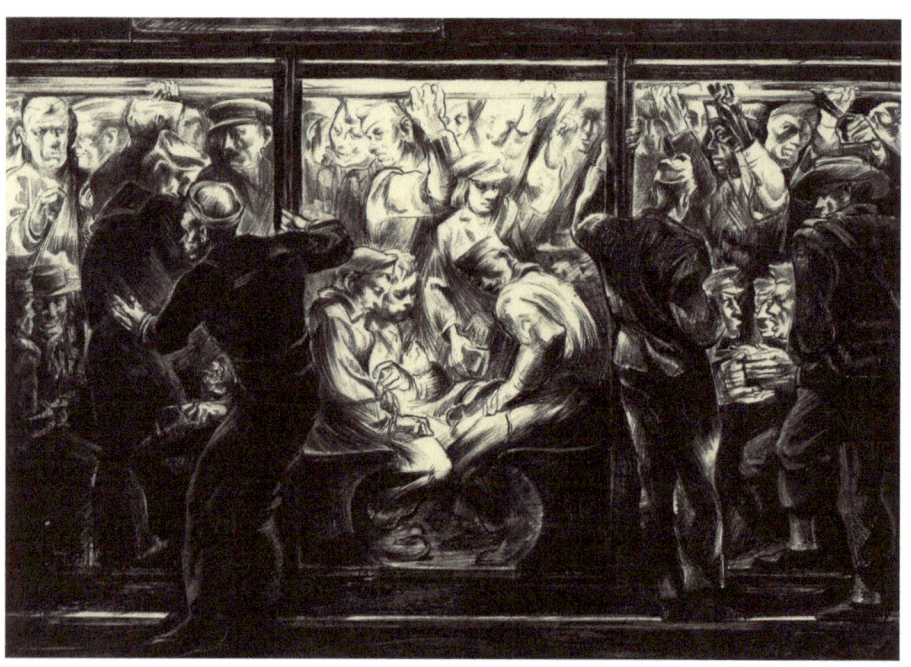
Last Train to Doonben, 1943

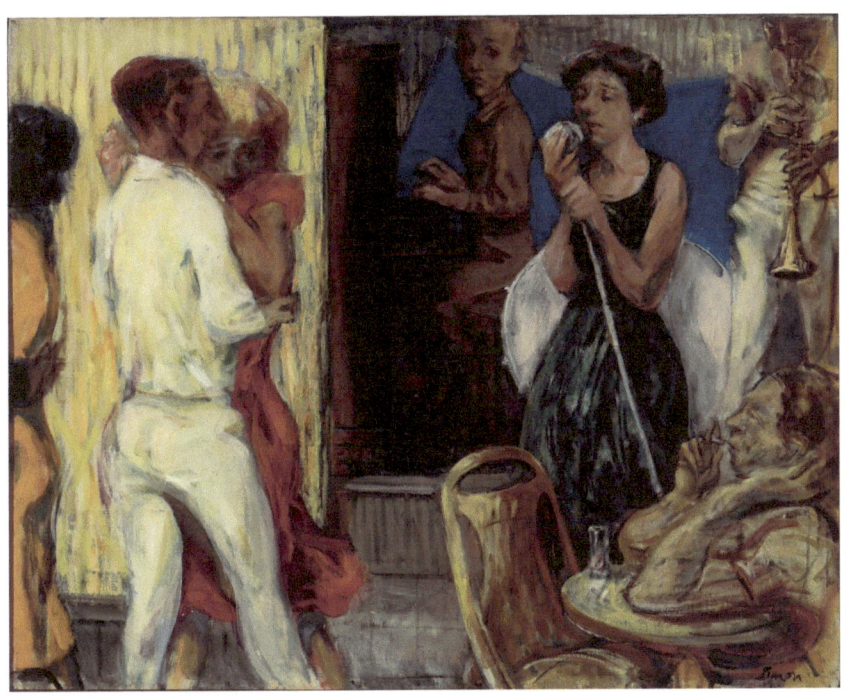

Paradise Cafe Paris, 1948

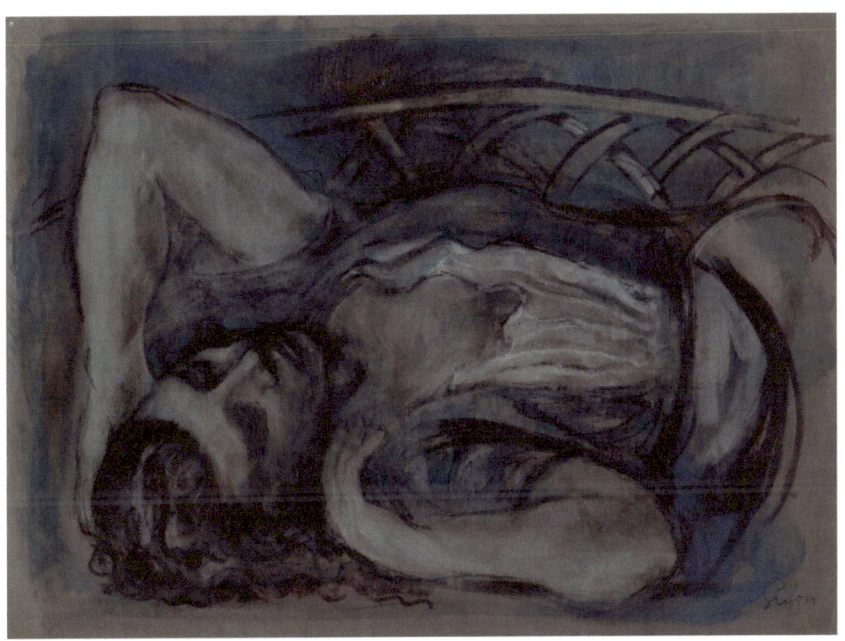

Untitled

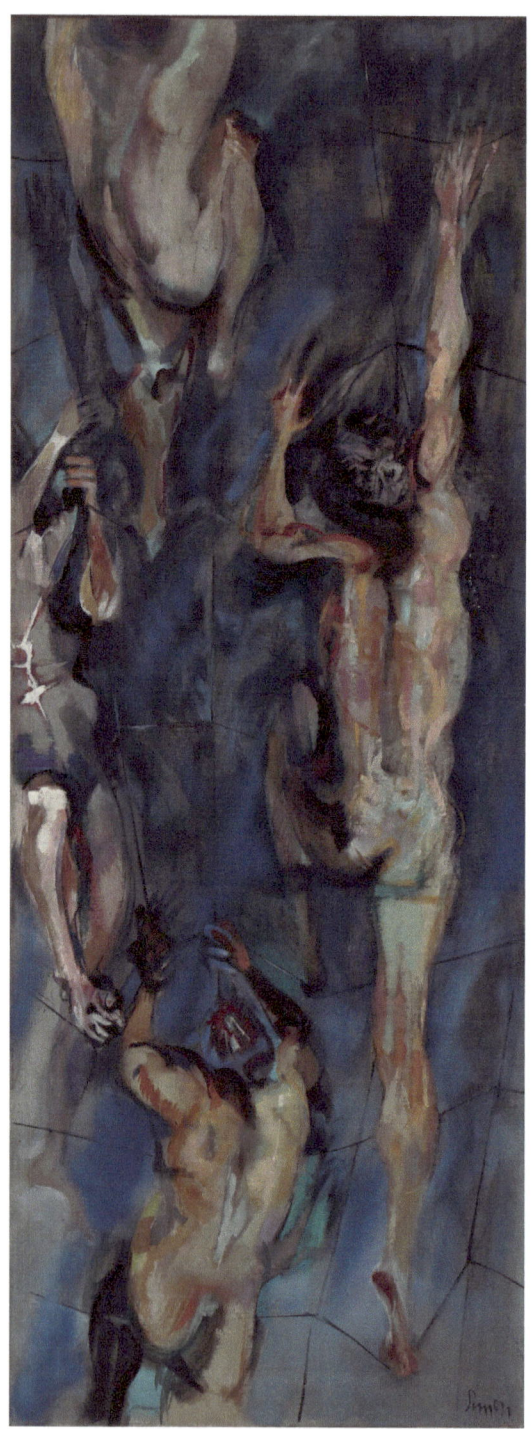

The Climbers, 1954-56

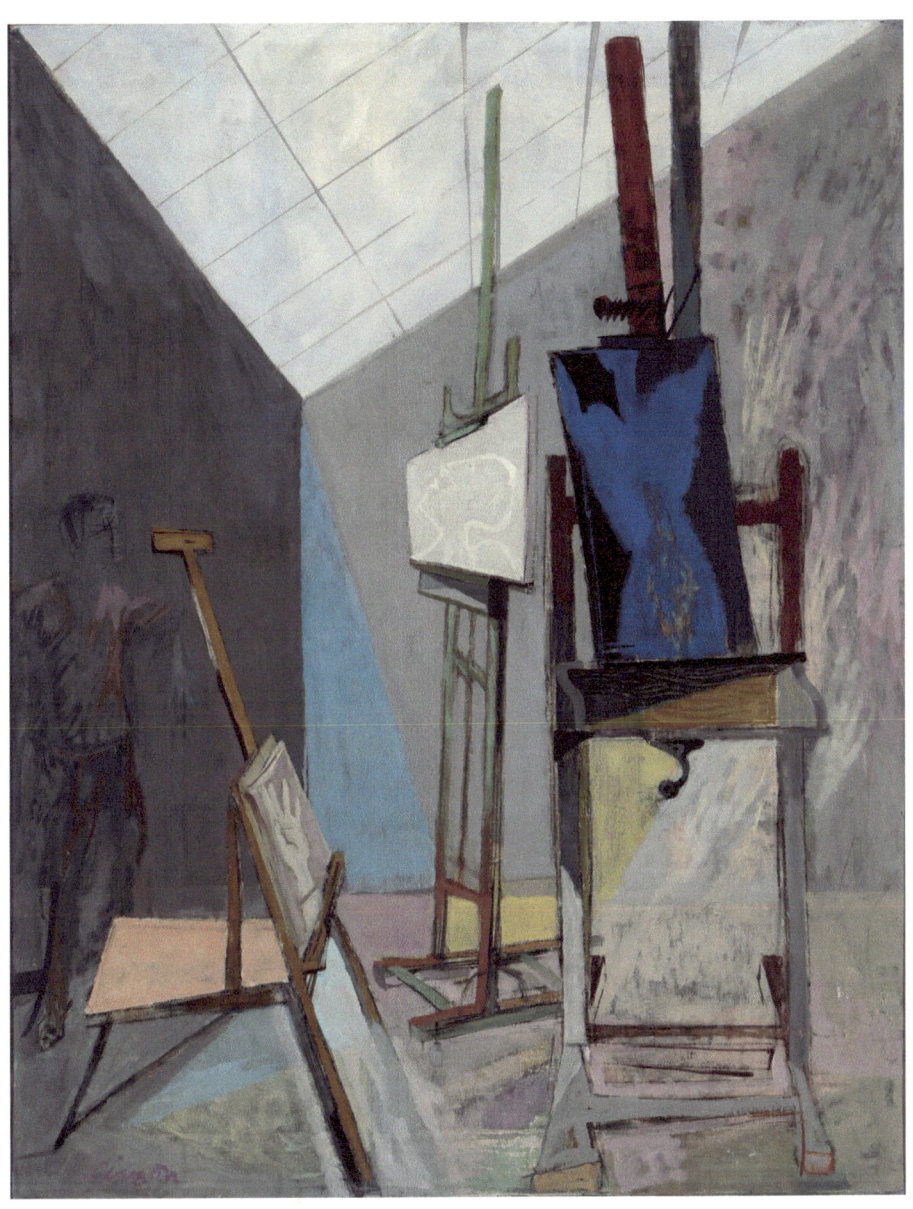

The Prison

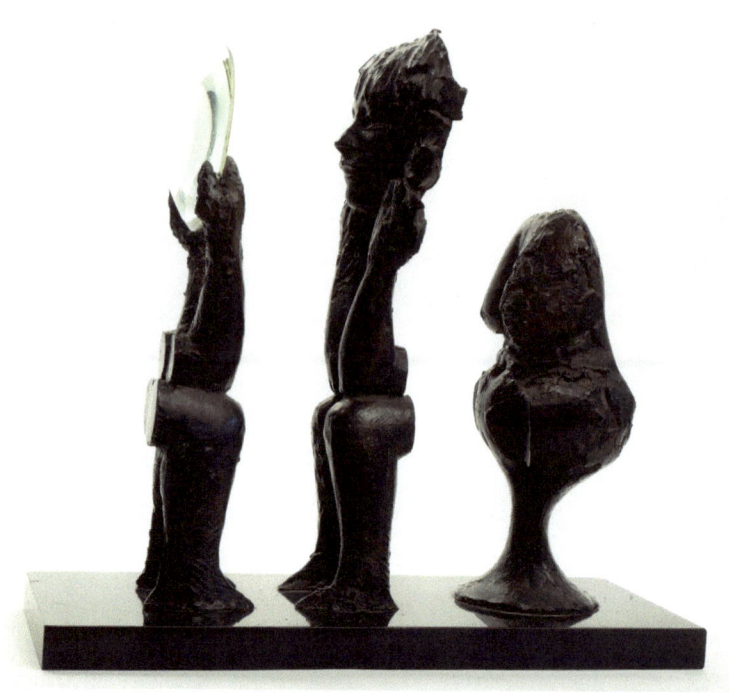
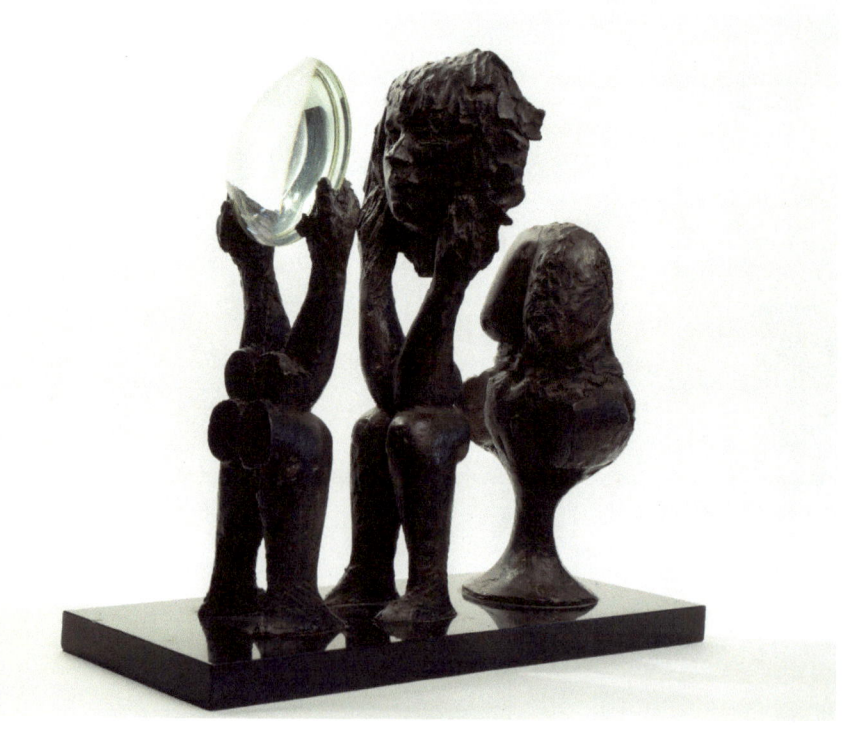

Mirror #5 - Torso, legs, face, prism

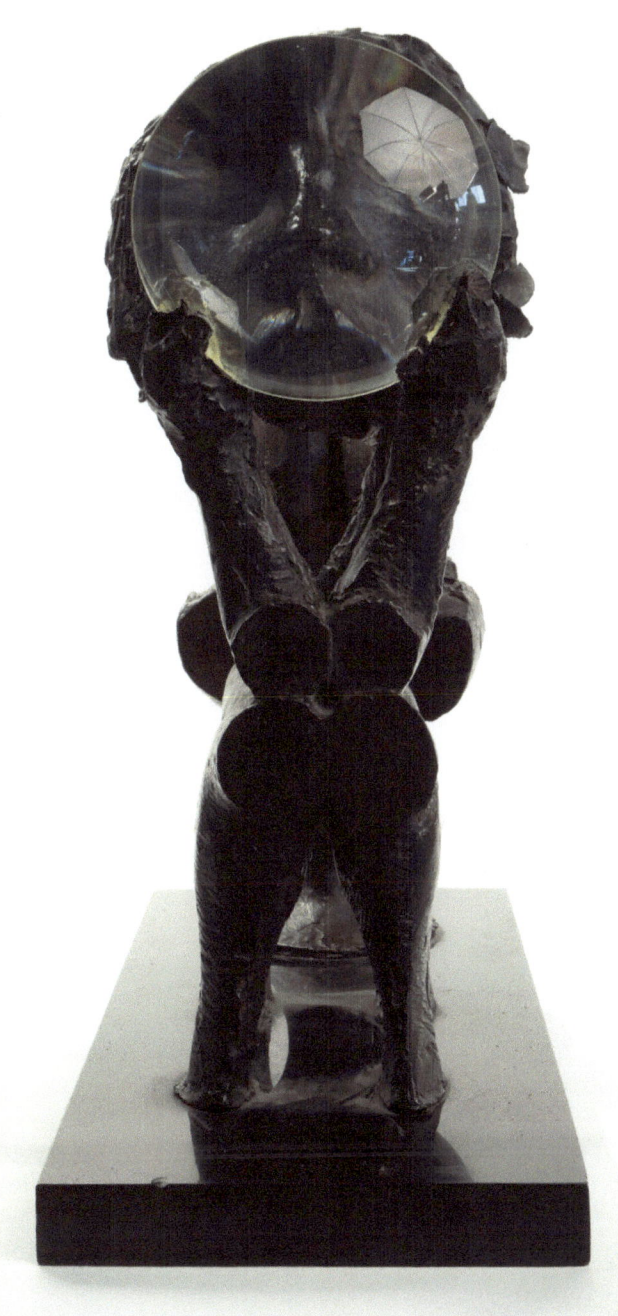

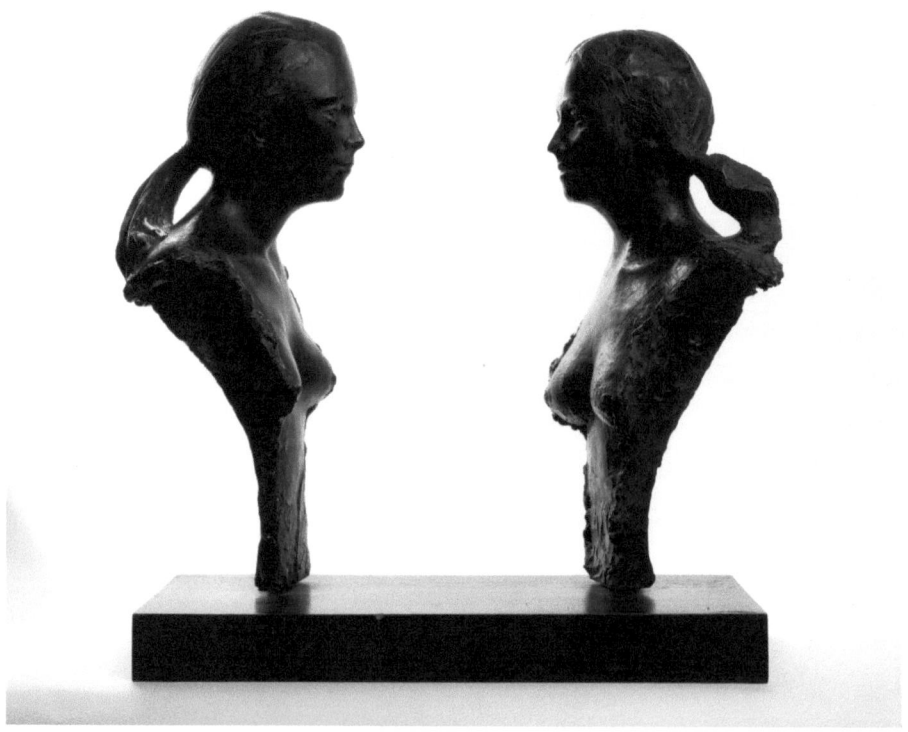

Sisters

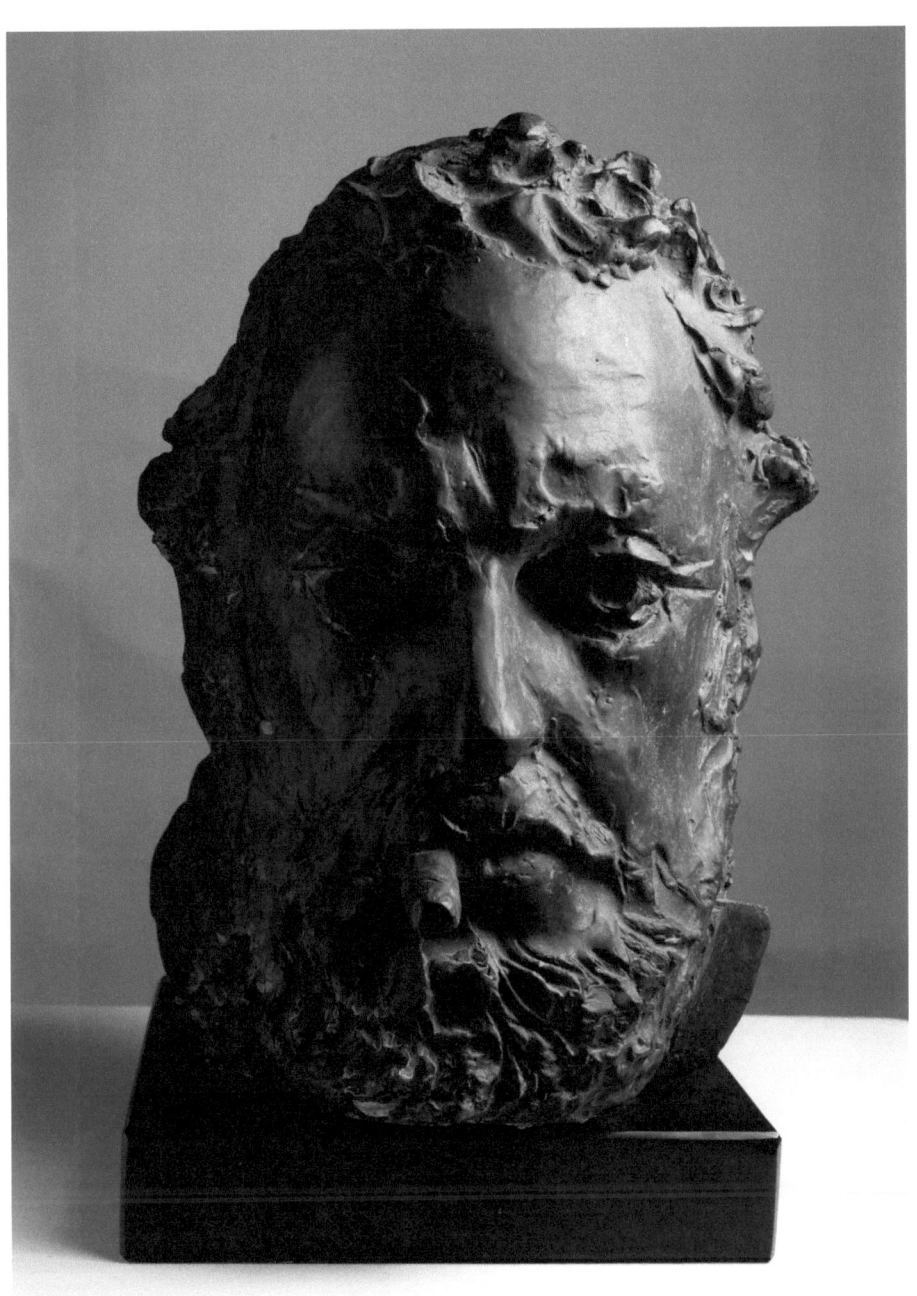
Portrait of Paul Resika

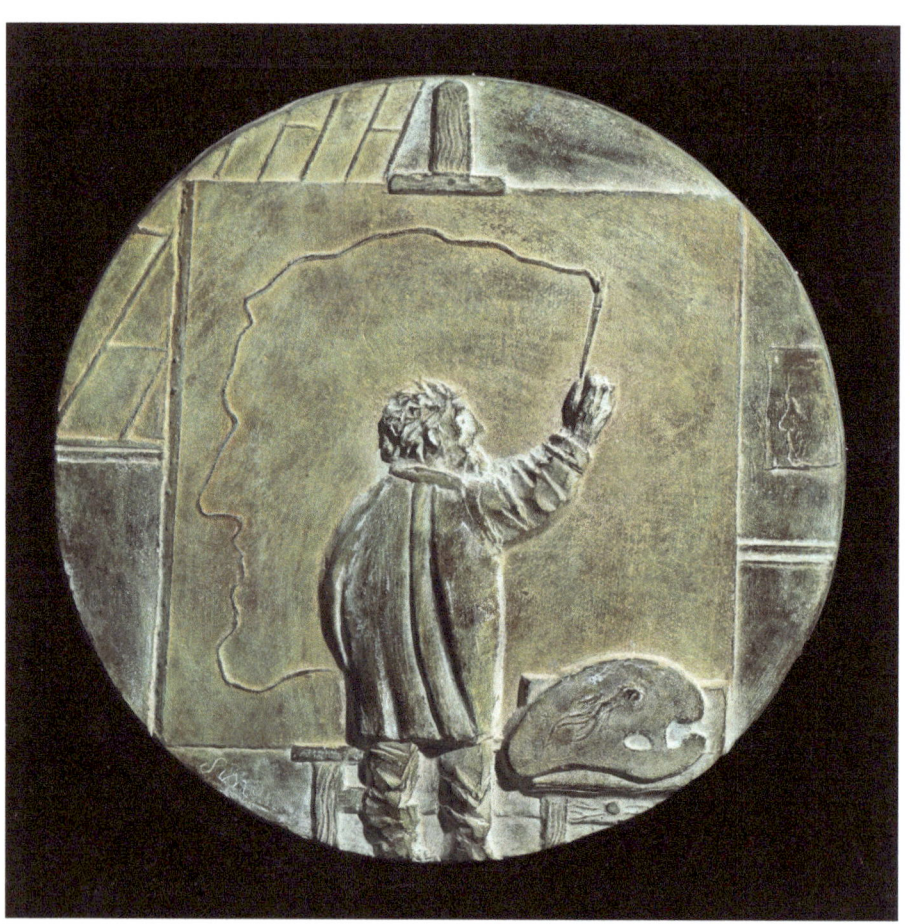
The artist drawing/self-portrait

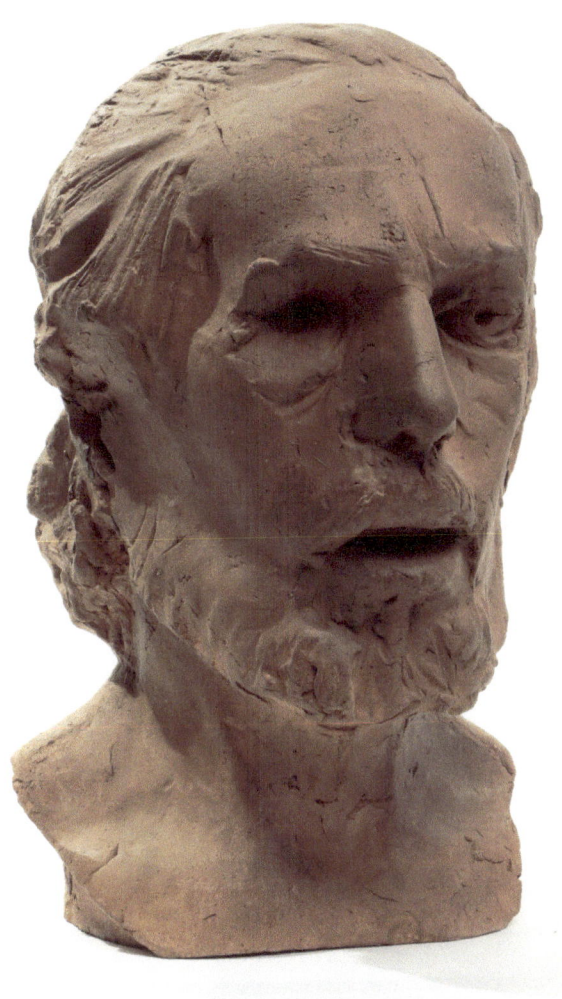
Self Portrait

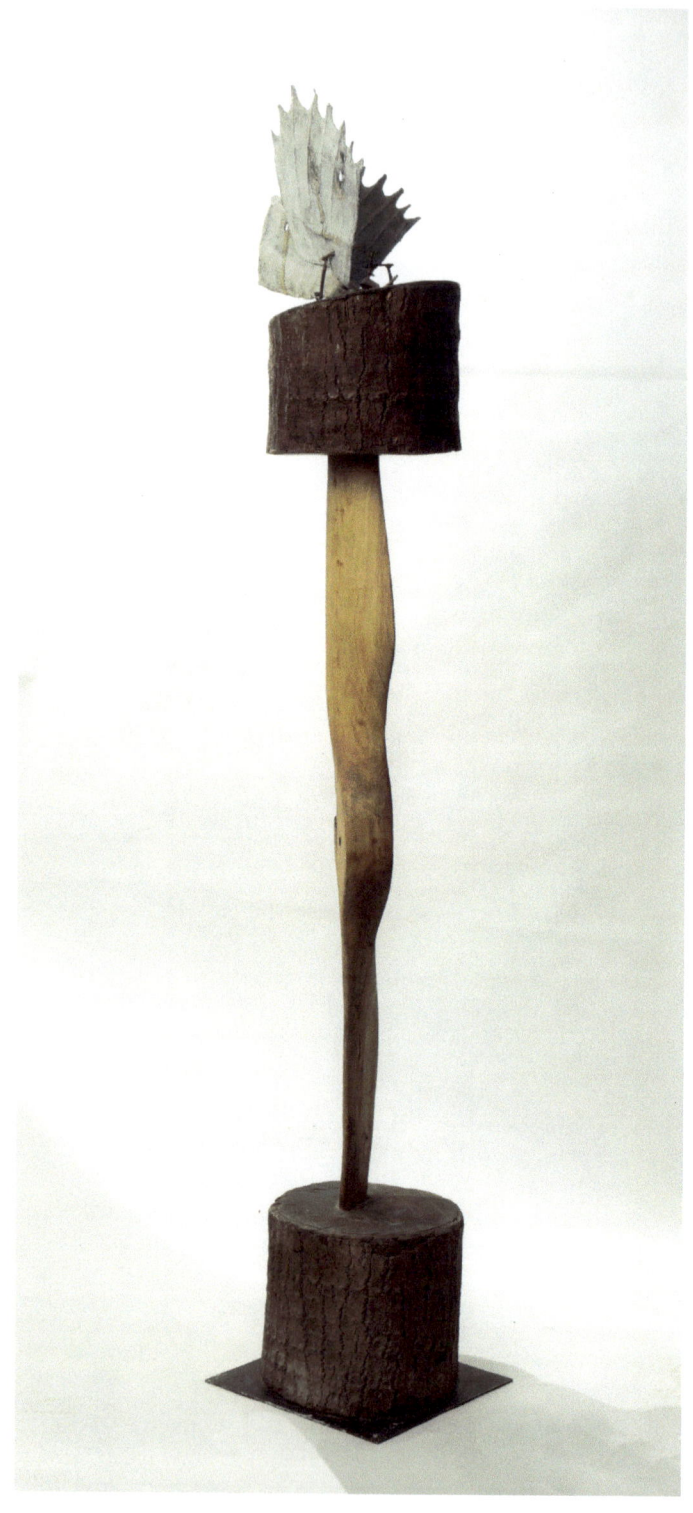
Icarus sculpture stand

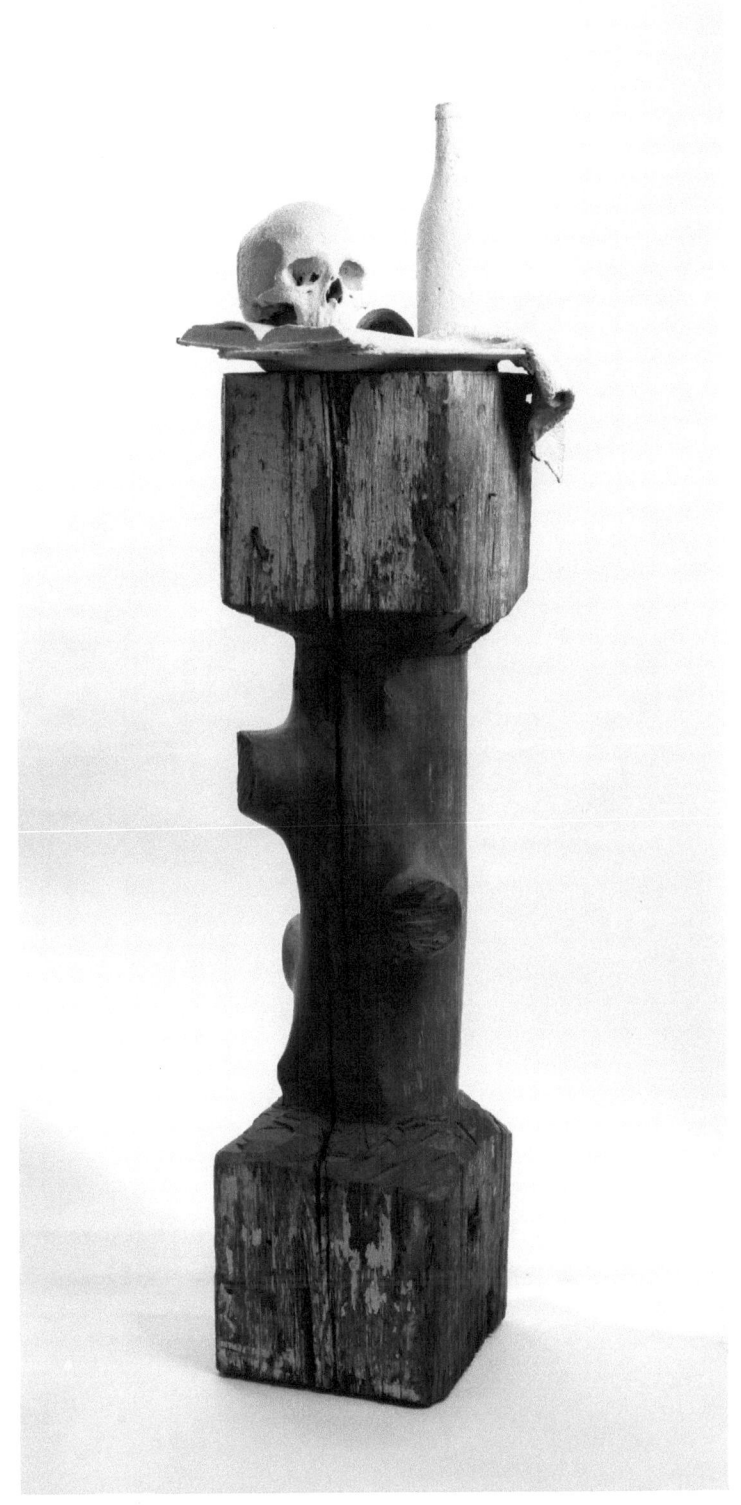

Still life sculpture stand

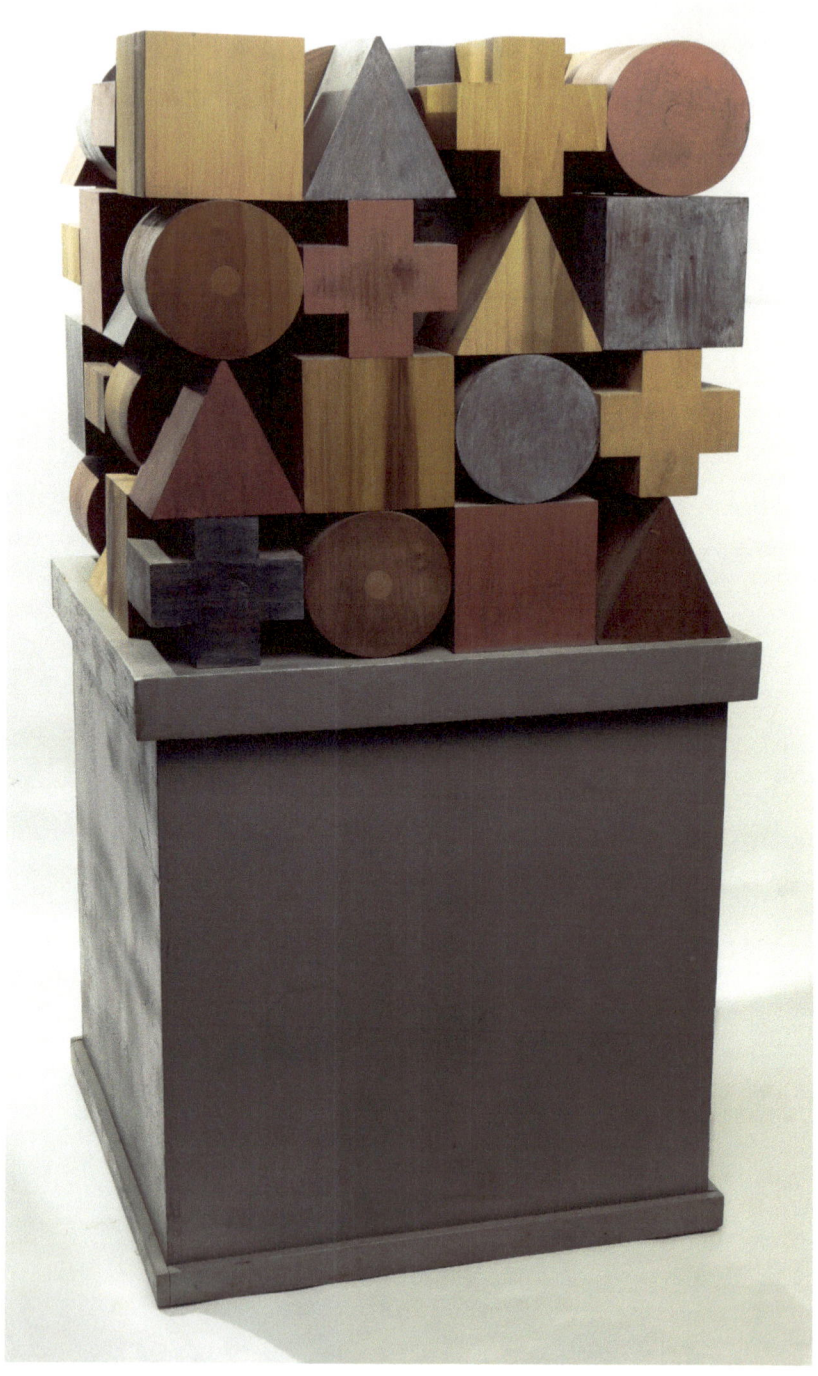

Puzzle Box

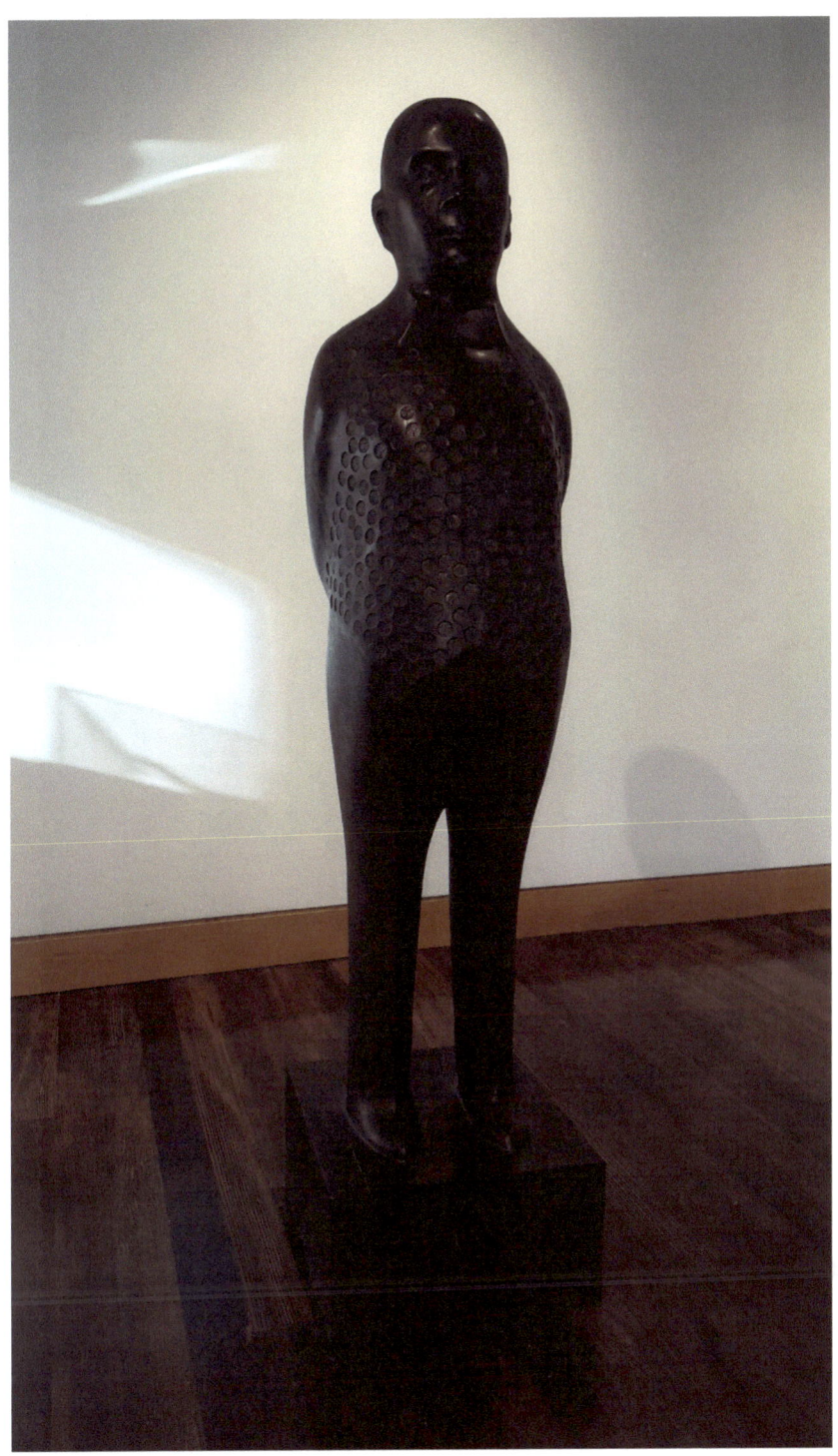

$4.95 – The Salesman (Portrait of the artist's father)

Sidney Simon, 1960s

www.ingramcontent.com/pod-product-compliance
Lightning Source LLC
Chambersburg PA
CBHW041118180526
45172CB00001B/313